ORIGAMI
wild animals

John Montroll

DOVER PUBLICATIONS, INC.
Mineola, New York

Bibliographical Note

This Dover edition, first published in 2004, is a new selections of designs from *Origami for the Enthusiast* (1979) and *Animal Origami for the Enthusiast* (1985) by John Montroll, both previously published by Dover Publications, Inc.

International Standard Book Number: 0-486-43970-4

Manufactured in the United States of America
Dover Publications, Inc., 31 East 2nd Street, Mineola, N.Y. 11501

INTRODUCTION

Origami is a challenging and unusual art. It requires square sheets of paper, which are formed into sculptures of animals or other objects by the process of folding.

Origami can be folded from almost any paper, but is most attractive when made from special paper called origami paper. Origami paper is square and usually comes in packets of assorted sizes and colors. It may be found in many variety and hobby stores. Difficult projects are easier to fold if you use the larger sizes of paper. The back side of each sheet of origami paper is white. In this book the colored side of the paper is indicated by the shaded areas.

It is important that you follow the directions carefully. The standard folds, from which the animals are created, are explained in detail at the beginning of the book. I have used the Randlett-Yoshizawa method of notation to indicate the folds.

The following rules should help guide you through the metamorphosis of folding. Examine step one; if there are any creased-folds in the square, fold them first. Make all further folds according to the instructions provided by lines, arrows and captions. Be aware of the instructions in the next step so that you know what each fold will become. Fold slowly and accurately and crease each fold with your fingernail to keep the folds crisp.

Contents

Symbols

Lines

— — — — — — — — — Valley fold, fold in front.

— · — · · — · — · · — · — · Mountain fold, fold behind.

———————————— Crease line.

················· X-ray or guide line.

Arrows

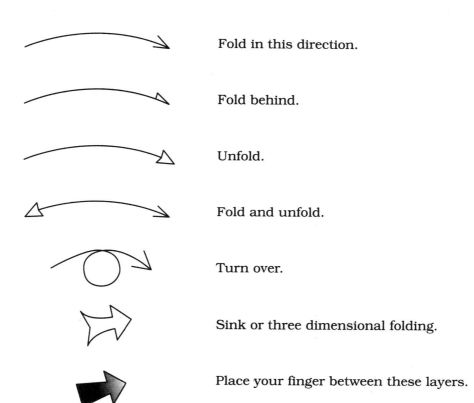

Fold in this direction.

Fold behind.

Unfold.

Fold and unfold.

Turn over.

Sink or three dimensional folding.

Place your finger between these layers.

Basic Folds

Rabbit Ear.

To fold a rabbit ear, one corner is folded in half and laid down to a side.

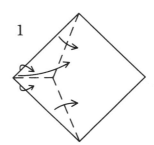

1

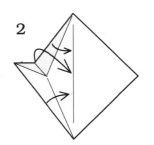

2

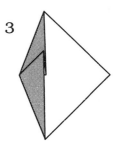

3

Fold a rabbit ear.

A three-dimensional intermediate step.

Double Rabbit Ear.

If you were to bend a straw you would be folding the double rabbit ear.

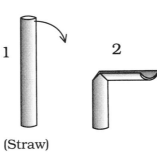

1 2

(Straw)

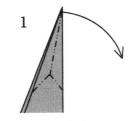

1

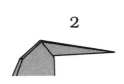

2

Make a double rabbit ear.

Squash Fold.

In a squash fold, some paper is opened and then made flat. The shaded arrow shows where to place your finger.

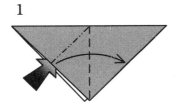

1

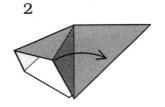

2

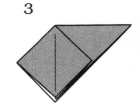

3

Squash-fold.

A three-dimensional intermediate step.

Petal Fold.

In a petal fold, one point is folded up while two opposite sides meet each other.

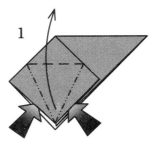

1

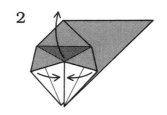

2

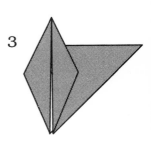

3

Petal-fold.

A three-dimensional intermediate step.

Inside Reverse Fold.

In an inside reverse fold, some paper is folded between layers. Here are two examples.

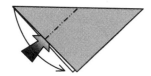

1

2

Reverse-fold.

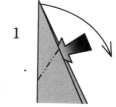

1

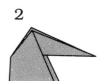

2

Reverse-fold.

Outside Reverse Fold.

Much of the paper must be unfolded to make an outside reverse fold.

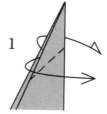

1

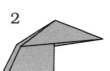

2

Outside-reverse-fold.

Crimp Fold.

A crimp fold is a combination of two reverse folds.

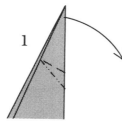

1

2

Crimp-fold.

Sink Fold.

In a sink fold, some of the paper without edges is folded inside. To do this fold, much of the model must be unfolded.

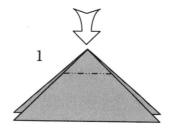

1

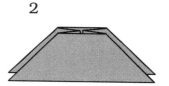

2

Sink.

Spread Squash Fold.

A cross between a squash fold and sink fold, some paper in the center is spread apart and then made flat.

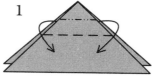

1

2

Spread-squash-fold.

Preliminary-fold

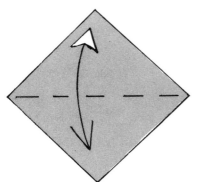

1. Fold diagonally in half, then unfold.

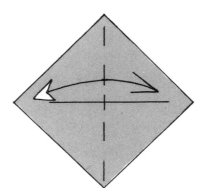

2. Repeat.

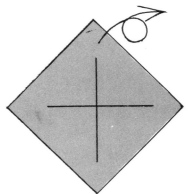

3. Turn over model, then turn clockwise.

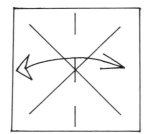

4. Fold in half, then unfold.

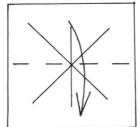

5. Fold in half.

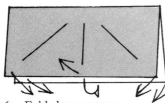

6a. Fold along creases.

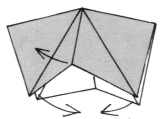

6b. Appearance just before completion.

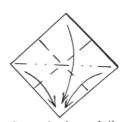

Synopsis of steps 1-6b.

7. **PRELIMINARY-FOLD**

Blintz-fold

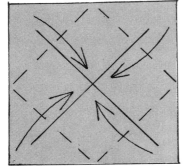

1. Fold and unfold diagonally in half to form creases as shown, then fold four corners to center.

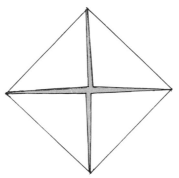

2. **BLINTZ-FOLD**

Pleat-fold

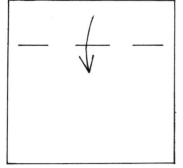

1. Valley-fold. Fold forward.

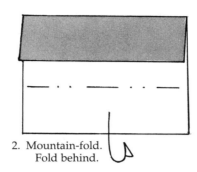

2. Mountain-fold. Fold behind.

3. Finished model displaying both folds.

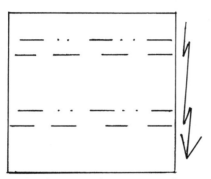

4. Combination of mountain-and valley-folds.

5. PLEAT-FOLD

Kite-fold

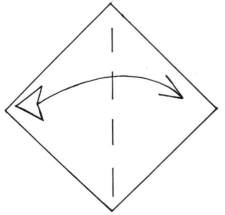

1. Fold diagonally in half, then unfold.

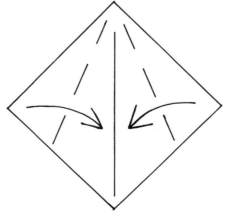

2. Valley-fold along lines to center crease.

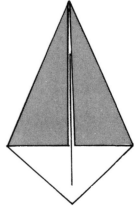

3. KITE-FOLD

Wing-fold

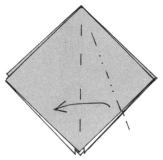

1. Begin with the preliminary-fold. Squash-fold.

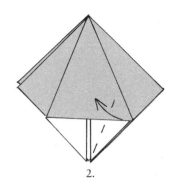

2.

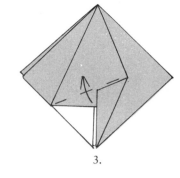

3.

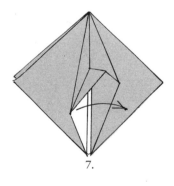

4.

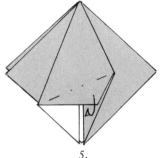

5.

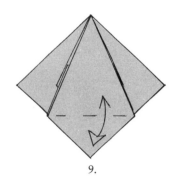

6.

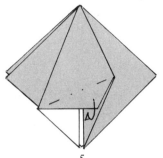

7.

8. Repeat steps 1–7 on the left side.

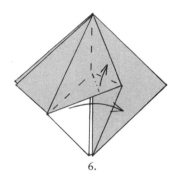

9.

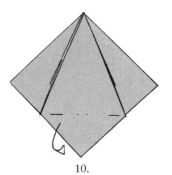

10.

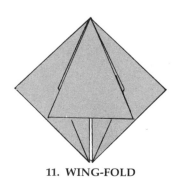

11. **WING-FOLD**

Snake

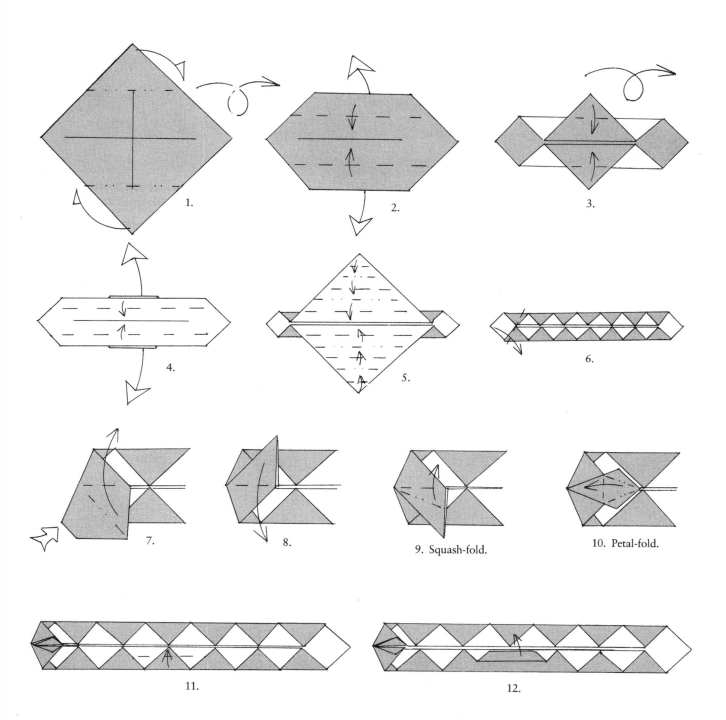

9. Squash-fold.

10. Petal-fold.

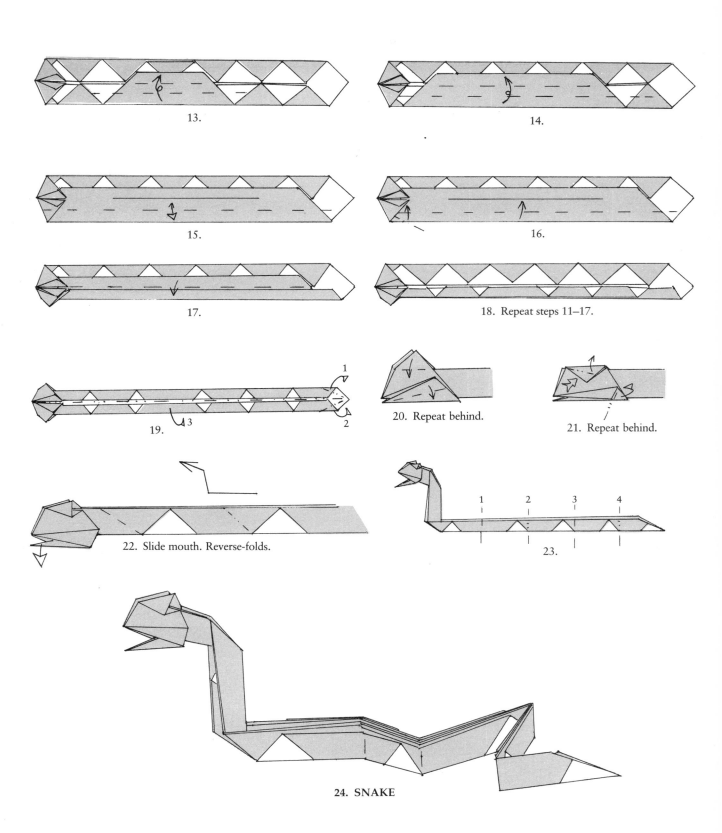

13.

14.

15.

16.

17.

18. Repeat steps 11–17.

19.

20. Repeat behind.

21. Repeat behind.

22. Slide mouth. Reverse-folds.

23.

24. SNAKE

Bear

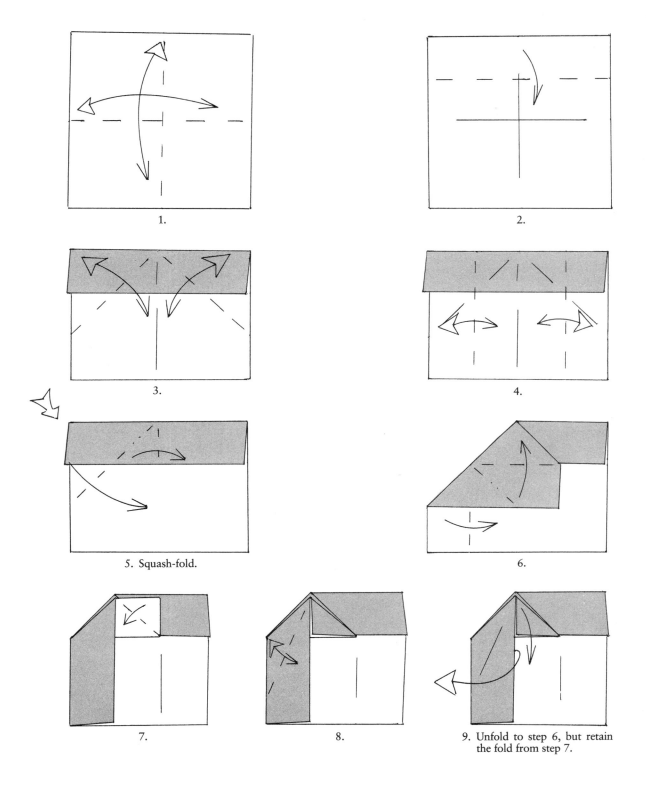

1.

2.

3.

4.

5. Squash-fold.

6.

7.

8.

9. Unfold to step 6, but retain the fold from step 7.

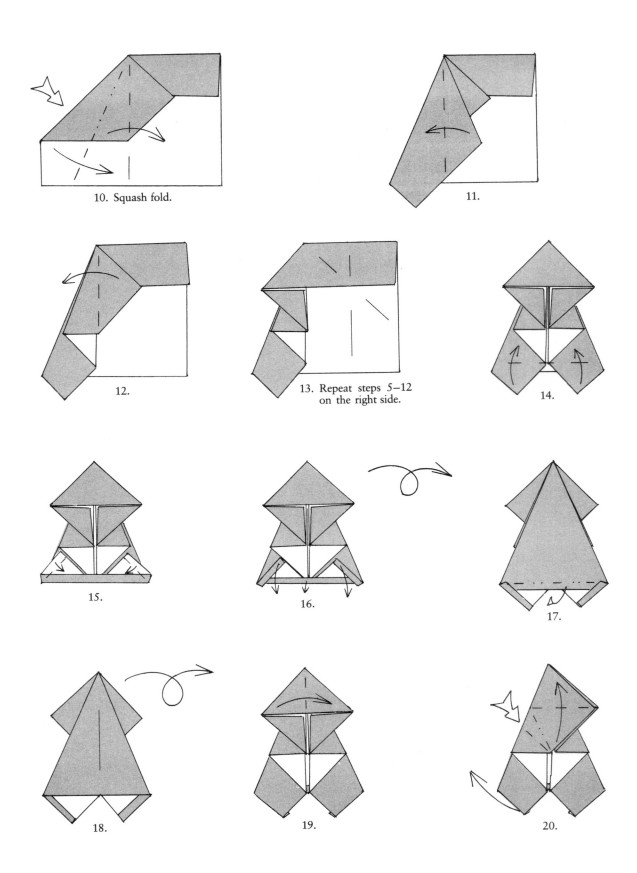

10. Squash fold.

11.

12.

13. Repeat steps 5–12 on the right side.

14.

15.

16.

17.

18.

19.

20.

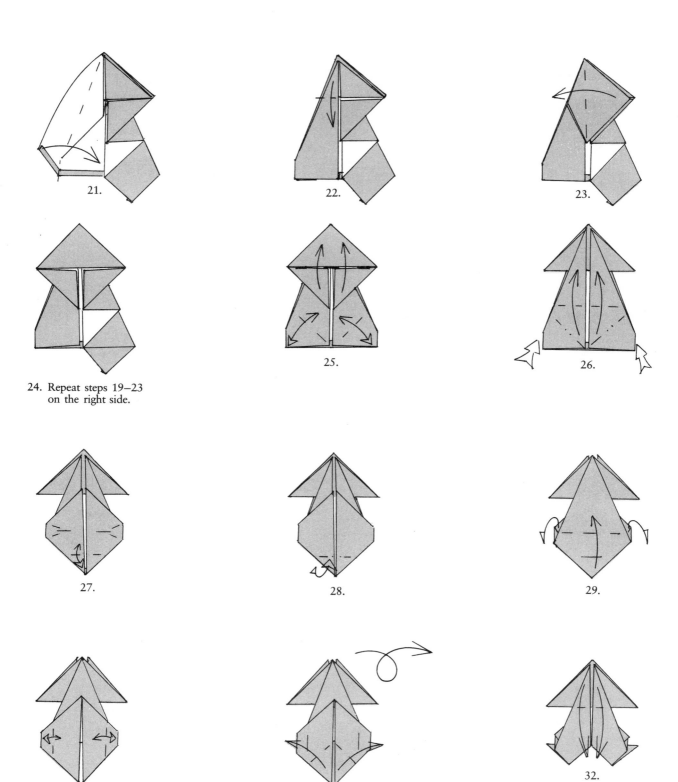

21.

22.

23.

24. Repeat steps 19–23
on the right side.

25.

26.

27.

28.

29.

30.

31.

32.

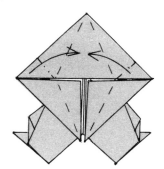

33. Rabbit ears.

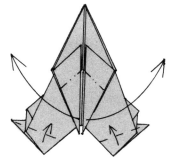

34. Reverse-folds.

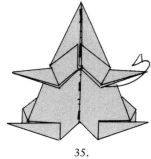

35.

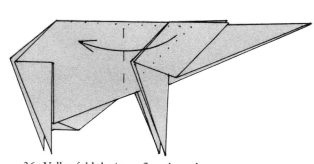

36. Valley-fold the inner flap along the crease made in steps 27 & 28 to lock the model. This fold is done inside the body.

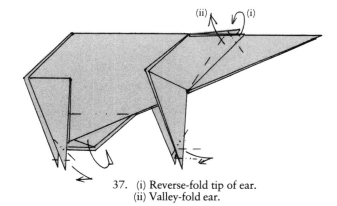

37. (i) Reverse-fold tip of ear.
 (ii) Valley-fold ear.

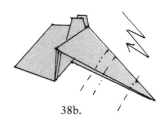

38a. Outside crimp-fold the head.

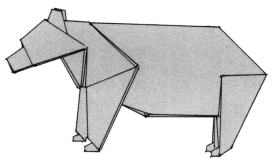

38b.

39. BEAR

Kangaroo

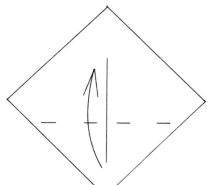

1. Crease lightly.

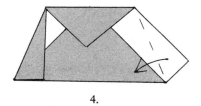

2. Crease lightly.

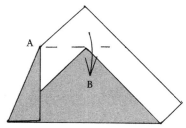

3. Check if A & B are on the same horizontal line. If not, adjust the folds from steps 1 & 2, then sharpen the creases.

4.

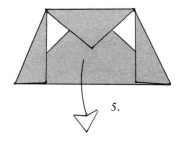

5.

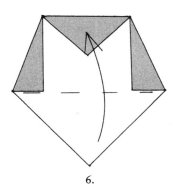

6.

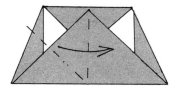

7. Squash-fold.

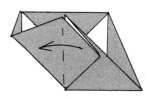

8.

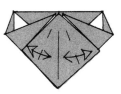

9. Repeat steps 7 & 8 on the right side.

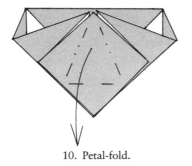

10. Petal-fold.

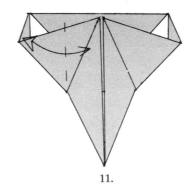

11.

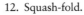
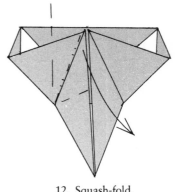

12. Squash-fold.

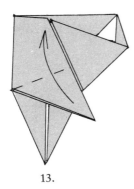

13.

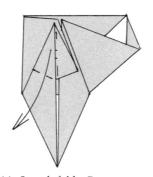

14. Squash-fold. Repeat steps 11–14 on the right side.

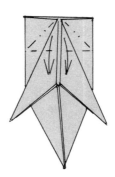

15. Squash-folds.

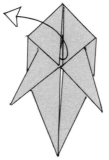

16. Pull out the inner flap (that was folded down in step 3).

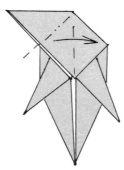

17. Squash-fold.

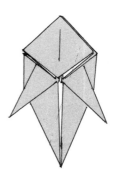

18. Wing-fold.

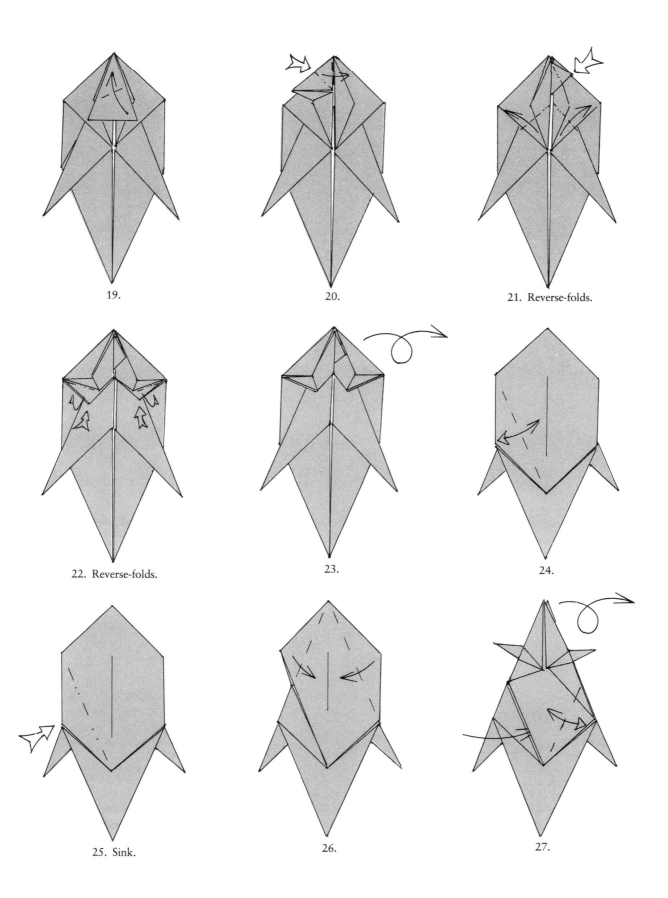

19.

20.

21. Reverse-folds.

22. Reverse-folds.

23.

24.

25. Sink.

26.

27.

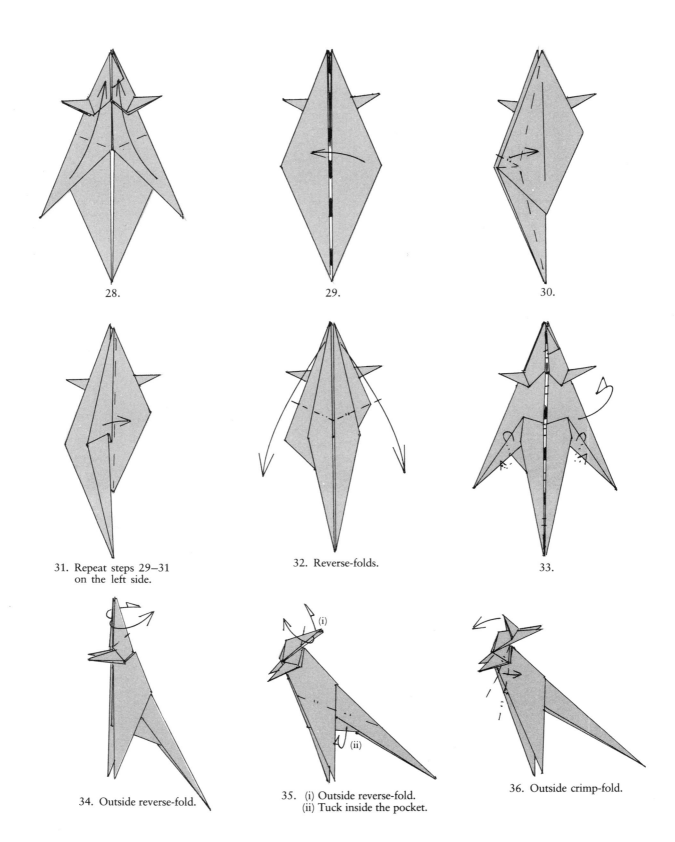

28.

29.

30.

31. Repeat steps 29–31 on the left side.

32. Reverse-folds.

33.

34. Outside reverse-fold.

35. (i) Outside reverse-fold.
 (ii) Tuck inside the pocket.

36. Outside crimp-fold.

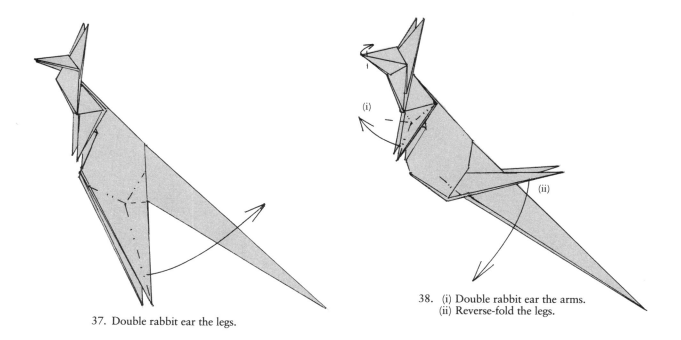

37. Double rabbit ear the legs.

38. (i) Double rabbit ear the arms.
 (ii) Reverse-fold the legs.

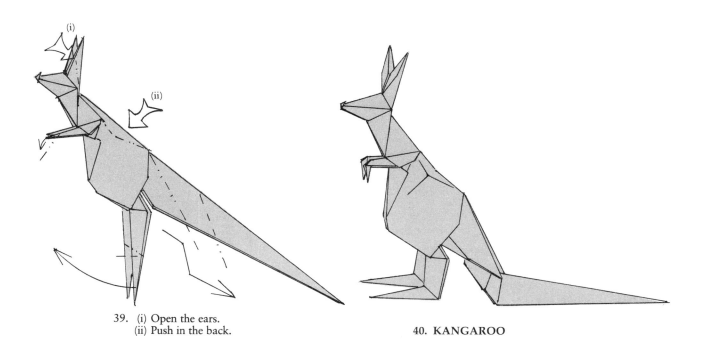

39. (i) Open the ears.
 (ii) Push in the back.

40. KANGAROO

Giraffe

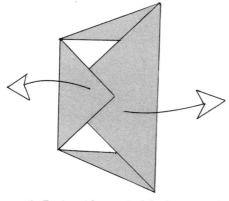

1. Begin with step 5 of the kangaroo (p. 17).

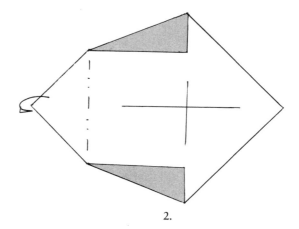

2.

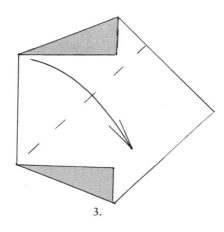

3.

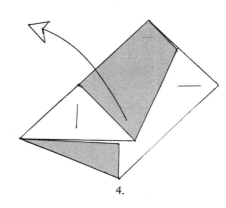

4.

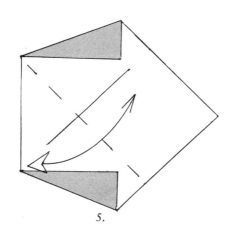

5.

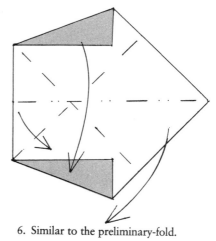

6. Similar to the preliminary-fold.

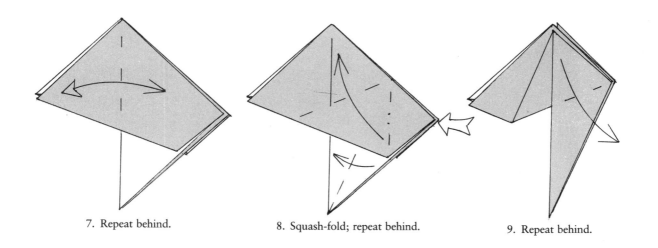

7. Repeat behind.

8. Squash-fold; repeat behind.

9. Repeat behind.

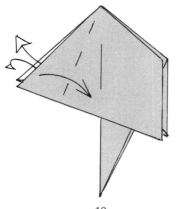

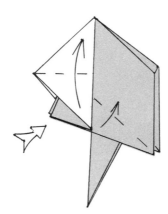

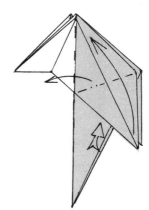

10.

11. Squash-fold; repeat behind.

12. Squash-fold; repeat behind.

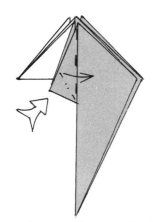

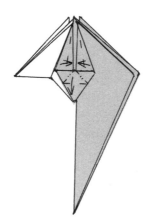

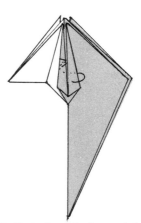

13. Squash-fold; repeat behind.

14. Petal-fold; repeat behind.

15. Tuck the right layer of the petal-fold under one layer; repeat behind.

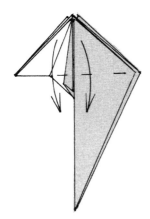

16. Repeat behind.

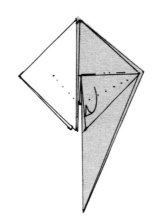

17. Mountain-fold the inner flap up and into the body; repeat behind.

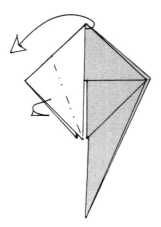

18.

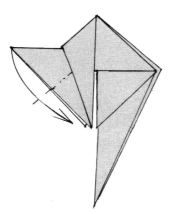

19. Reverse-fold.

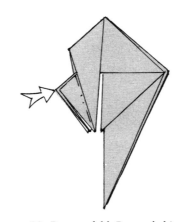

20. Reverse-fold. Repeat behind.

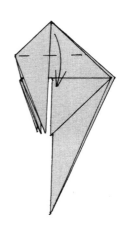

21.

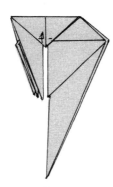

22.

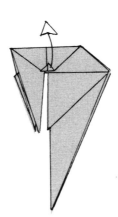

23. Unfold to step 21.

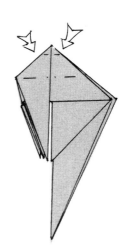

24. Sink triangularly.

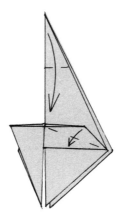

25. Reverse-fold.

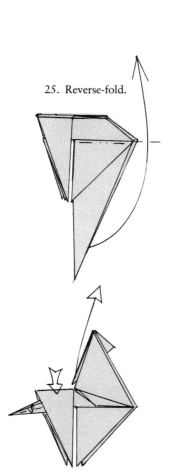

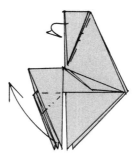

26. Repeat behind.

27. Crimp-fold the tail.

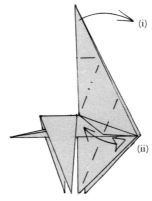

28. Reverse-fold to thin the tail;
repeat behind.

29. (i) Reverse-fold.
(ii) Repeat behind.

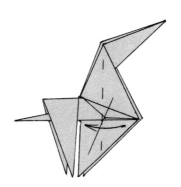

30. Repeat behind.

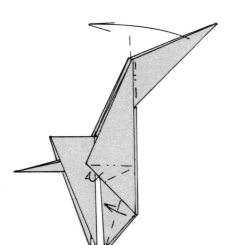

31. Reverse-fold; repeat behind.

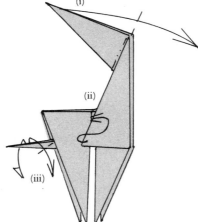

32. (i) Reverse-fold the head.
(ii) Tuck. Repeat behind.
(iii) Outside reverse-fold the tail.

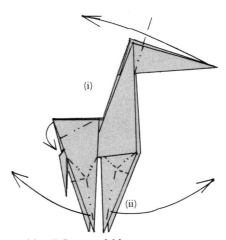

33. (i) Reverse-folds.
(ii) Double rabbit ear the legs;
repeat behind.

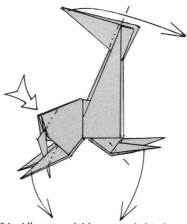

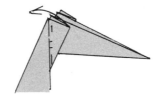

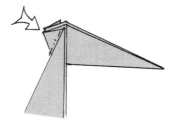

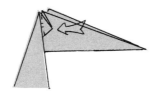

34. All reverse-folds; repeat behind.

35a. Head. Reverse-fold; repeat behind.

35b. Reverse-fold; repeat behind.

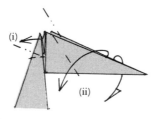

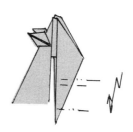

35c. Reverse-fold; repeat behind.

35d. (i) Squash-fold; repeat behind.
 (ii) Outside reverse-fold the head. Note that it does not come to a point at the horns.

35e.

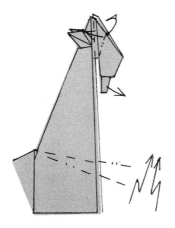

35f. Crimp-fold.

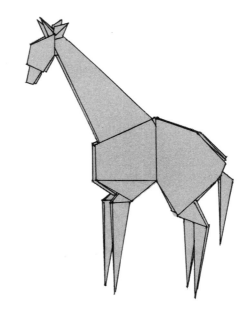

36. GIRAFFE

Fox

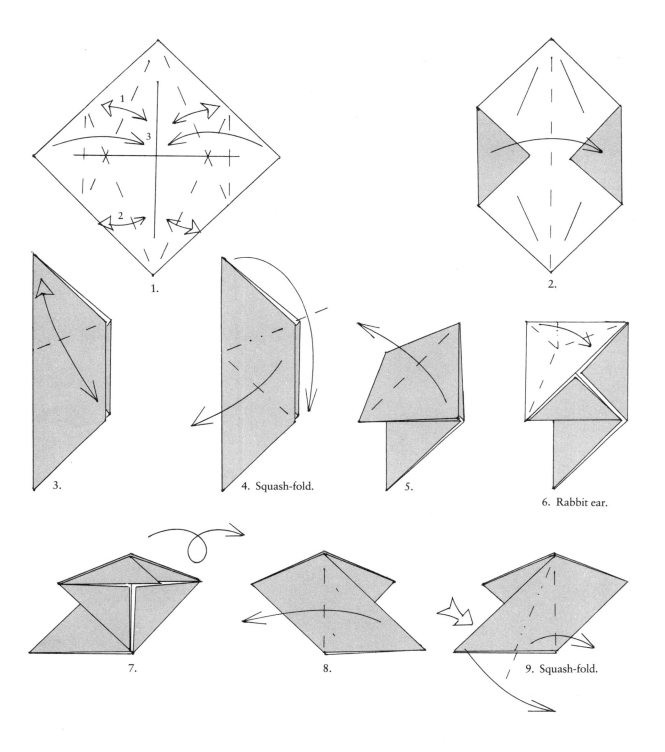

1.

2.

3.

4. Squash-fold.

5.

6. Rabbit ear.

7.

8.

9. Squash-fold.

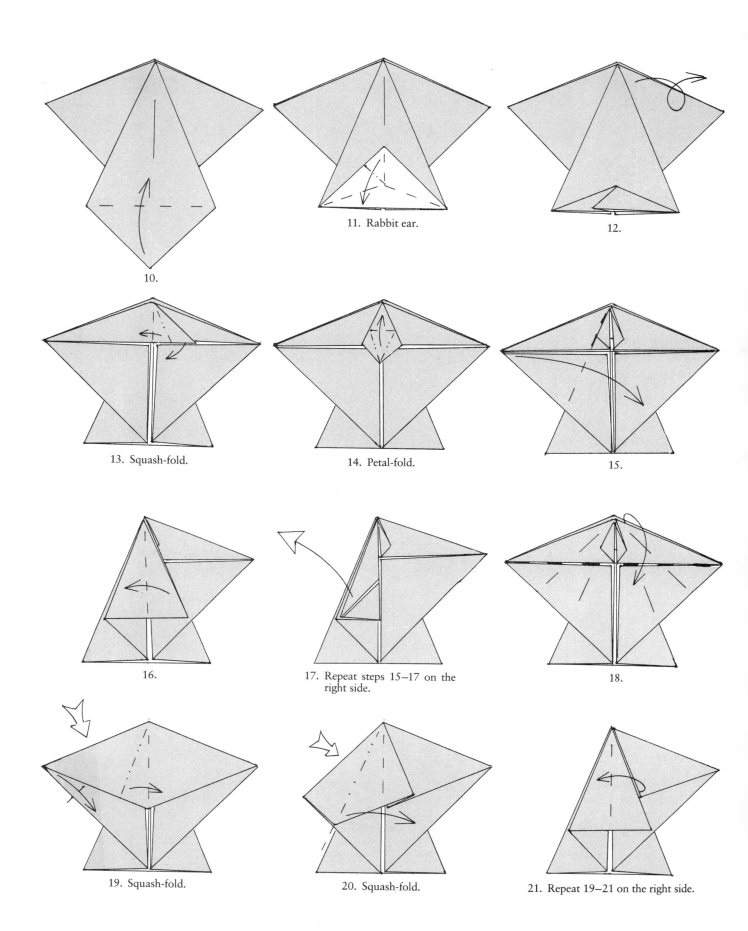

10.

11. Rabbit ear.

12.

13. Squash-fold.

14. Petal-fold.

15.

16.

17. Repeat steps 15–17 on the right side.

18.

19. Squash-fold.

20. Squash-fold.

21. Repeat 19–21 on the right side.

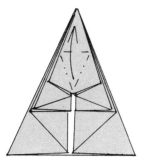

22. Unlock to fold up.

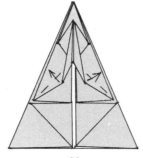

23.

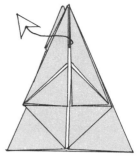

24. Pull out the flap.

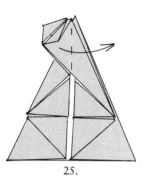

25.

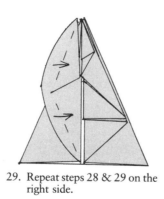

26. Squash-fold.

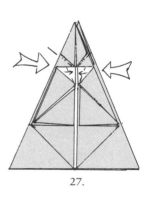

27.

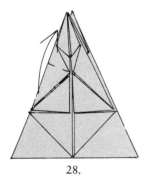

28.

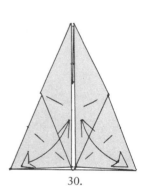

29. Repeat steps 28 & 29 on the right side.

30.

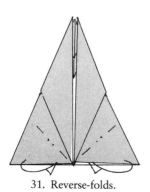

31. Reverse-folds.

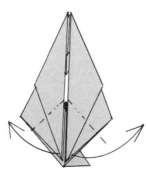

32. Reverse-folds.

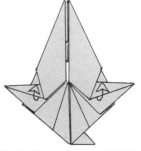

33. Pull out a layer and fold it on top. This is similar to an outside reverse-fold.

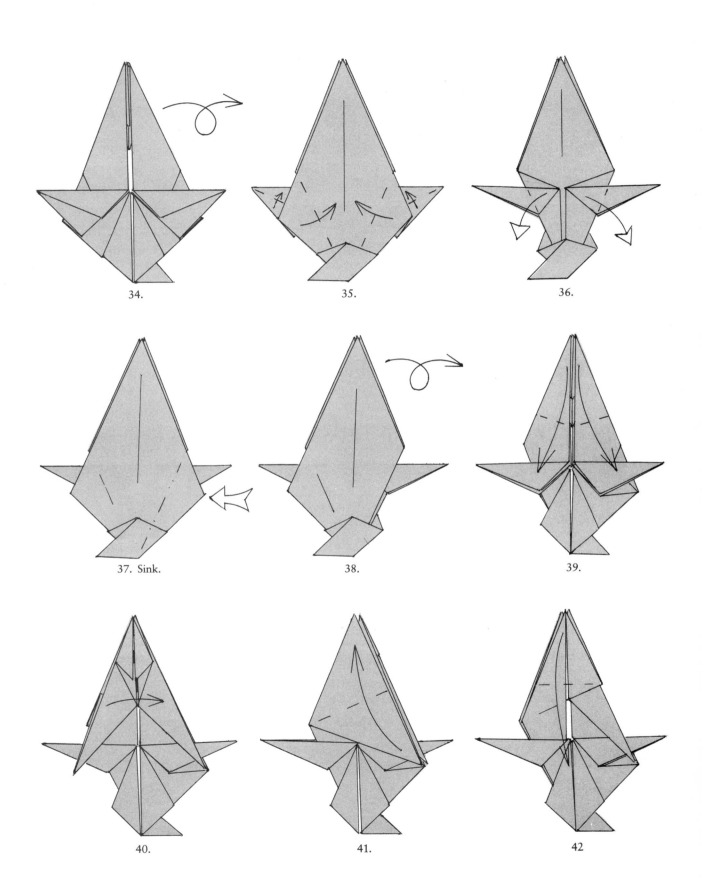

34.

35.

36.

37. Sink.

38.

39.

40.

41.

42

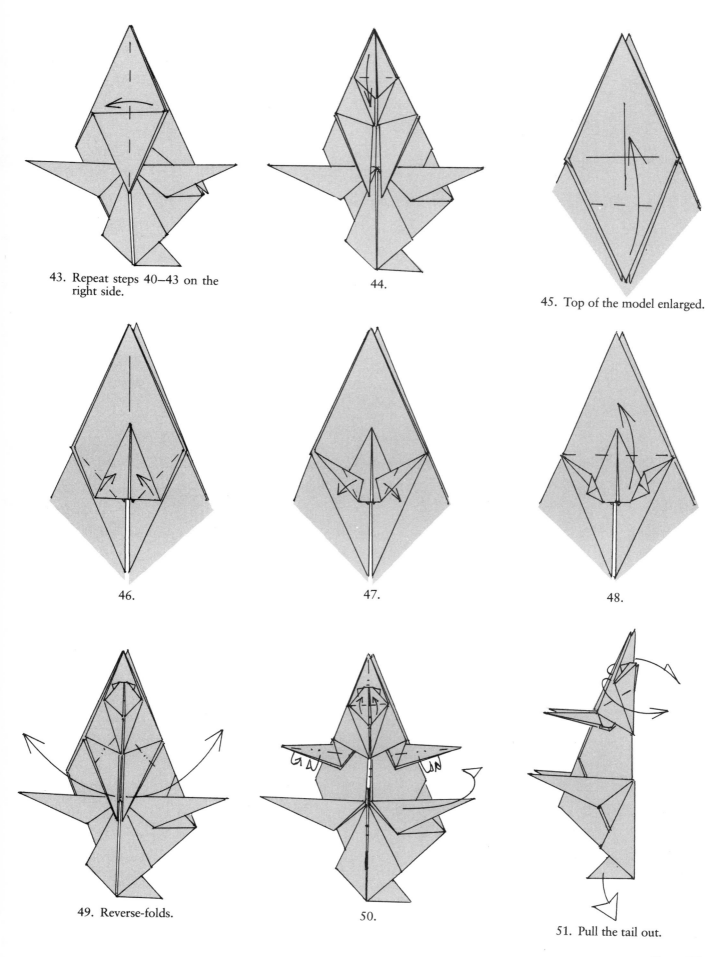

43. Repeat steps 40–43 on the right side.

44.

45. Top of the model enlarged.

46.

47.

48.

49. Reverse-folds.

50.

51. Pull the tail out.

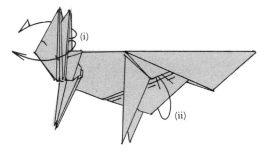

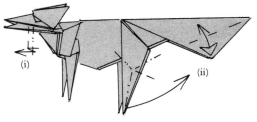

52. (i) Outside reverse-fold the head.
 (ii) Fold inside the pocket to lock
 the animal.

53. (i) Crimp-fold the mouth.
 (ii) Double rabbit ear the legs.

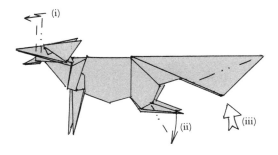

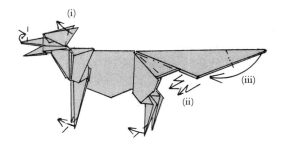

54. (i) Crimp-fold.
 (ii) Reverse-fold the legs.
 (iii) Sink.

55. (i) Outside reverse-fold to form
 the nose.
 (ii) Crimp the tail down.
 (iii) Reverse-fold the tip of the tail.

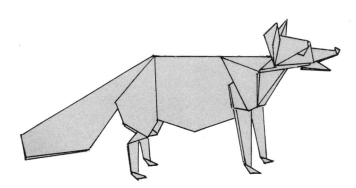

56. FOX

Elephant

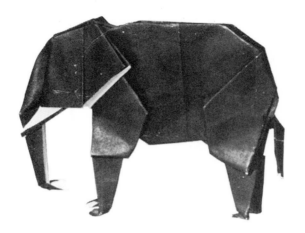

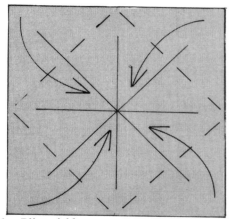

1. Blintz-fold.

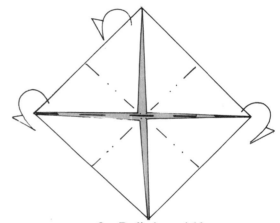

2. Preliminary-fold.

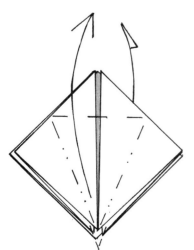

3. Petal-fold.

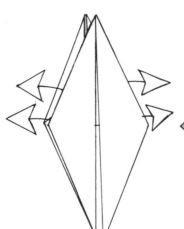

4. Pull out inner layers.

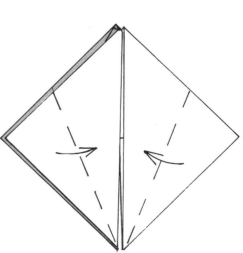

5. Kite-fold top layer.

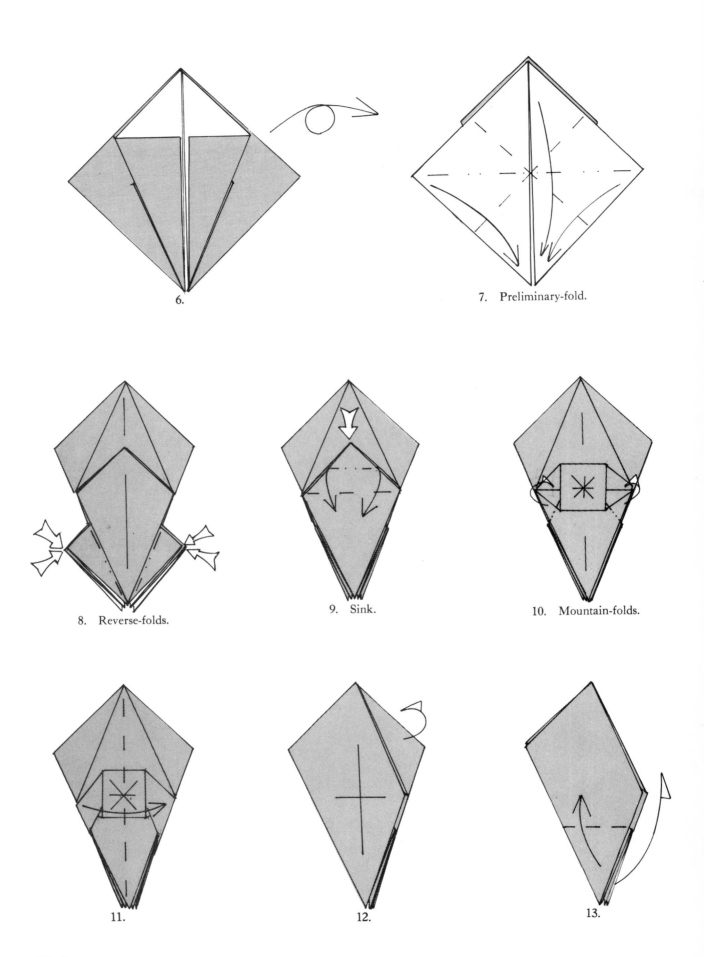

6.

7. Preliminary-fold.

8. Reverse-folds.

9. Sink.

10. Mountain-folds.

11.

12.

13.

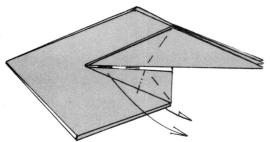

14. Rabbit ear; repeat behind.

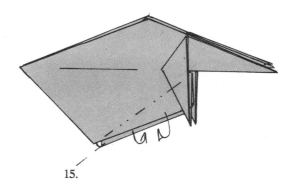

15.

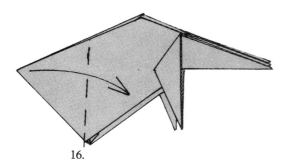

16.

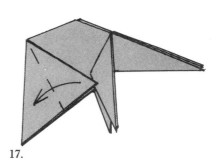

17.

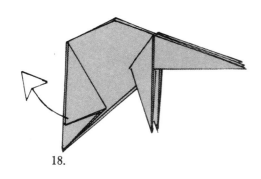

18.

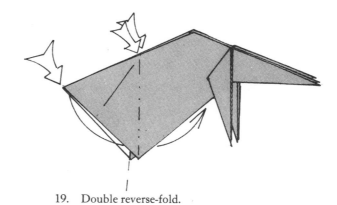

19. Double reverse-fold.

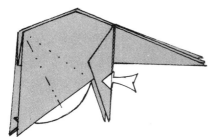

20. Double reverse-fold inner flap.

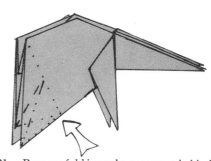

21. Reverse-fold inner layer; repeat behind.

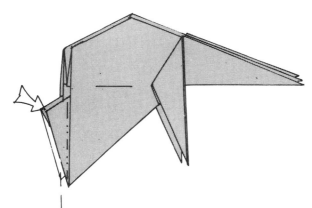

22. Reverse-fold; repeat behind.

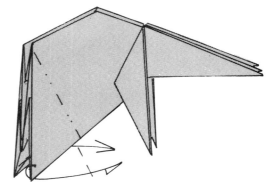

23. Reverse-fold; repeat behind. (Fold is not symmetrical.)

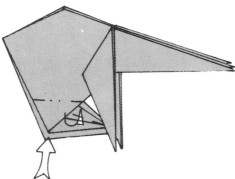

24. Reverse-fold; repeat behind.

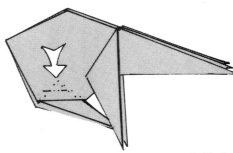

25. Reverse-fold inside layer; repeat behind.

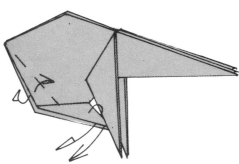

26. Fold legs down.

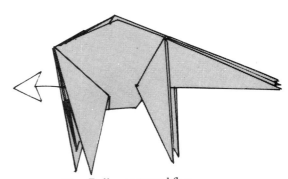

27. Pull out trapped flap.

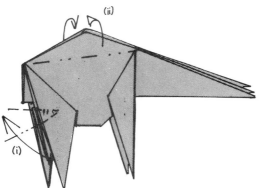

28. (i) Crimp-fold to form tail.
 (ii) Fold inside.

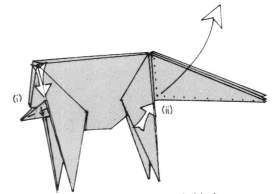

29. (i) Reverse-fold; repeat behind.
 (ii) Pull out the two layers between the three flaps.

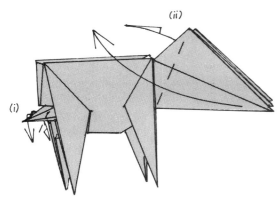

30. (i) Outside reverse-fold tail.
 (ii) Valley-fold outer layer; repeat behind.

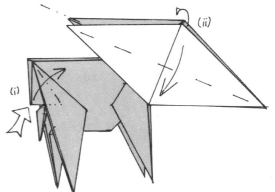

31. (i) Reverse-fold.
 (ii) Valley-fold; repeat behind.

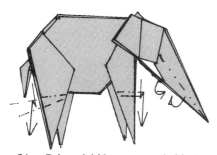

32. Reverse-fold; repeat behind.

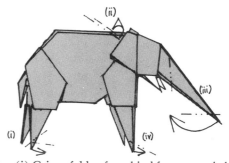

33. (i) Fold inside.
 (ii) Inside crimp-fold trunk. (Fold is not
 symmetrical.)

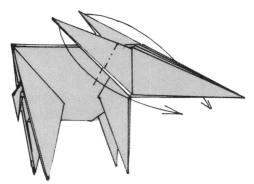

34. Crimp-fold legs; repeat behind.

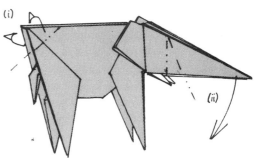

35. (i) Crimp-fold to form hind feet; repeat behind.
 (ii) Fold inside; repeat behind.
 (iii) Reverse-fold twice.
 (iv) Reverse-fold to form front feet; repeat behind.

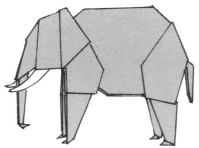

36. ELEPHANT

Antelope

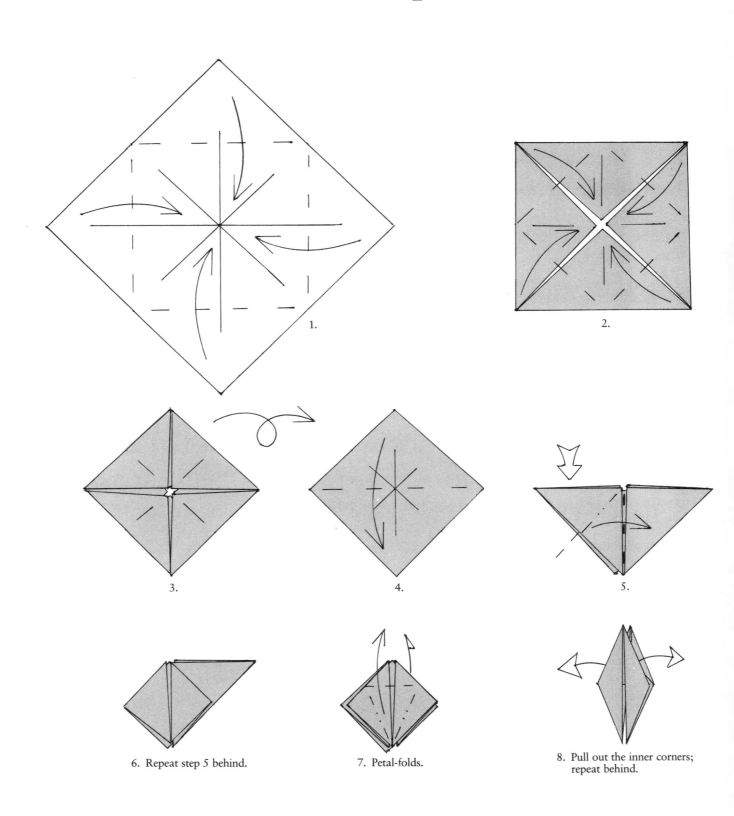

1.

2.

3.

4.

5.

6. Repeat step 5 behind.

7. Petal-folds.

8. Pull out the inner corners; repeat behind.

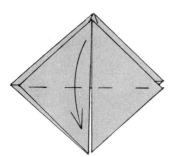

9. Repeat behind.

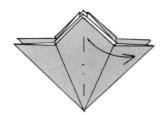

10. Snap out the top layer; repeat behind.

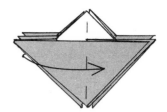

11. Repeat behind.

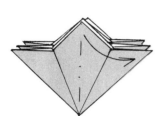

12. Repeat behind.

13.

14.

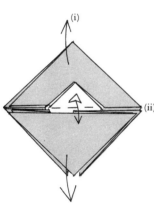

15. (i) Fold and unfold the white triangle.
 (ii) Pull.

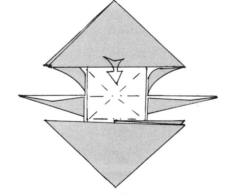

16. Sink.

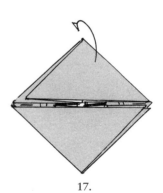

17.

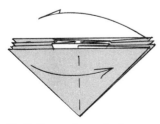

18. Fold two layers in front to the right and one layer in back to the left.

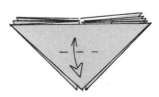

19. Note that the top layer is a bit locked and can only be folded up as high as the valley lines indicate. The same is true on the back.

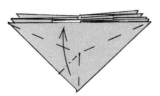

20. Rabbit ear.

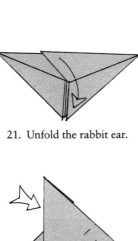

21. Unfold the rabbit ear.

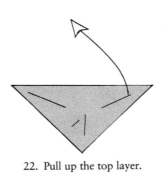

22. Pull up the top layer.

23.

24.

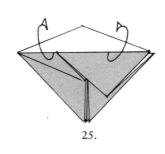

25.

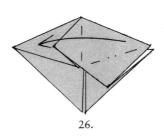

26.

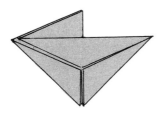

27. Repeat steps 20–26 behind.

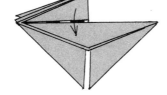

28. Repeat behind.

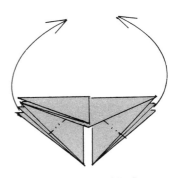

29. Pull out the middle flaps.

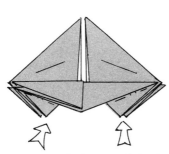

30. Reverse-folds; repeat behind.

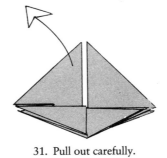

31. Pull out carefully.

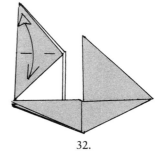

32.

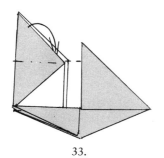

33.

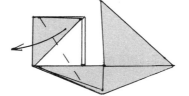

34. Repeat behind.

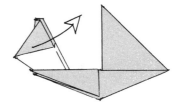

35. Repeat behind.

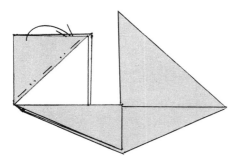

36. Reverse-fold.

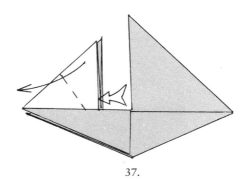

37.

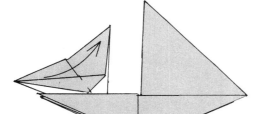

38.

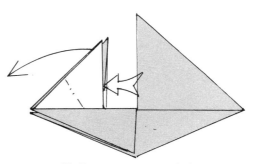

39. Repeat steps 37–39 behind.

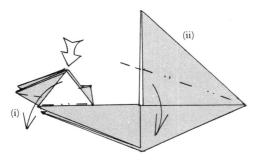

40. (i) Reverse-fold; repeat behind.
 (ii) Squash-fold.

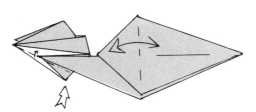

41. Repeat behind.

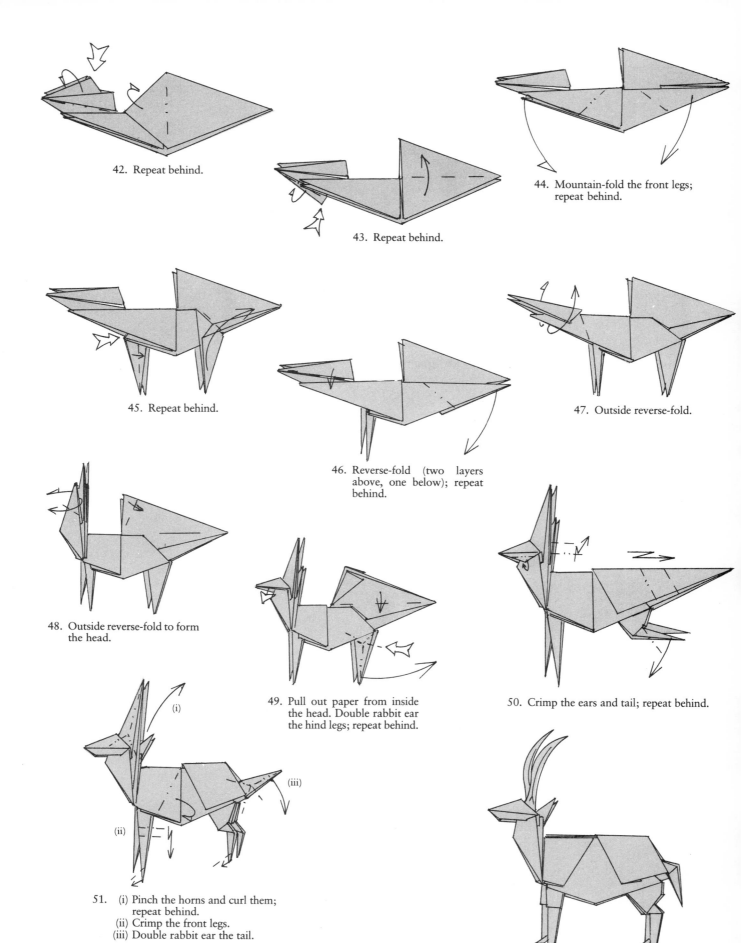

42. Repeat behind.

43. Repeat behind.

44. Mountain-fold the front legs; repeat behind.

45. Repeat behind.

46. Reverse-fold (two layers above, one below); repeat behind.

47. Outside reverse-fold.

48. Outside reverse-fold to form the head.

49. Pull out paper from inside the head. Double rabbit ear the hind legs; repeat behind.

50. Crimp the ears and tail; repeat behind.

51. (i) Pinch the horns and curl them; repeat behind.
 (ii) Crimp the front legs.
 (iii) Double rabbit ear the tail.

52. ANTELOPE

Rhinoceros

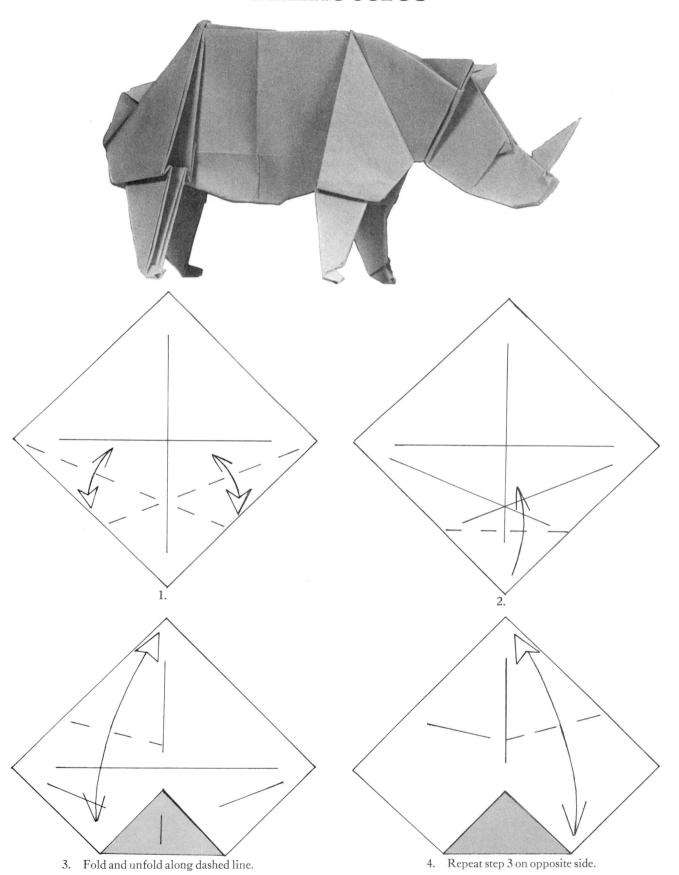

1.

2.

3. Fold and unfold along dashed line.

4. Repeat step 3 on opposite side.

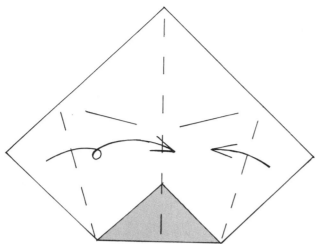

5. Fold flaps as shown, then fold model in half.

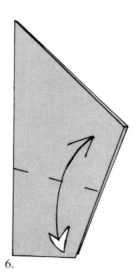

6.

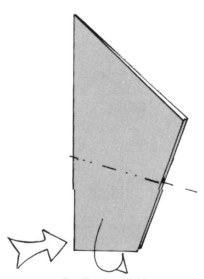

7. Reverse-fold.

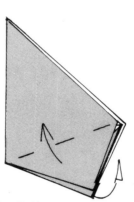

8. Fold up; repeat behind.

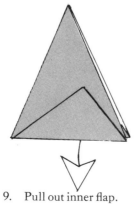

9. Pull out inner flap.

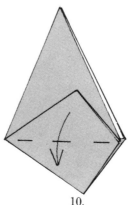

10.

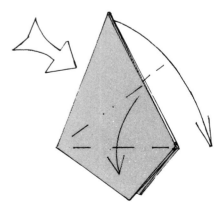

11. Squash-fold.

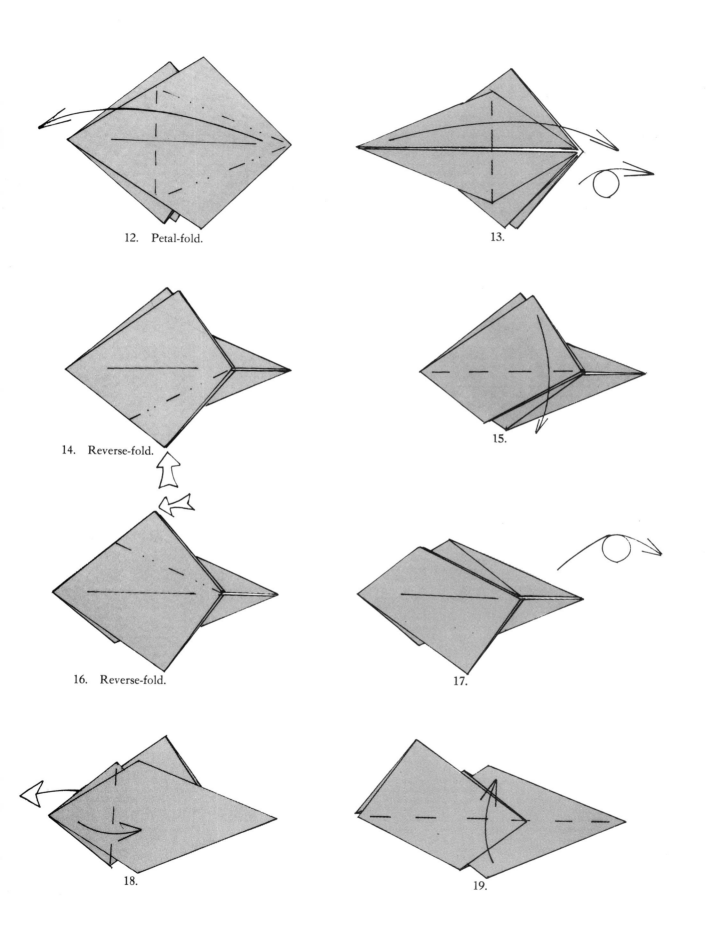

12. Petal-fold.

13.

14. Reverse-fold.

15.

16. Reverse-fold.

17.

18.

19.

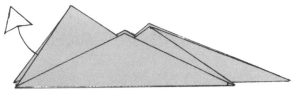

20. Pull out inner layer.

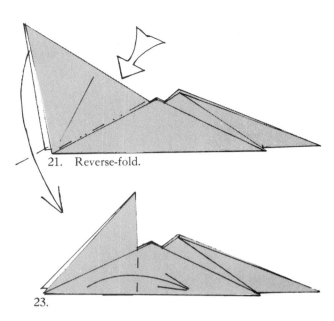

21. Reverse-fold.

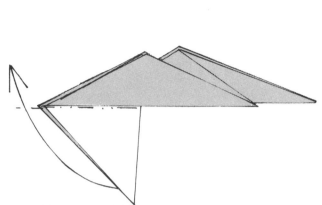

22. Reverse-fold.

23.

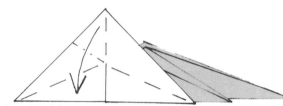

24. Rabbit ear.

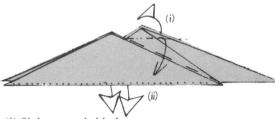

25.

26. (i) Sink; repeat behind.
 (ii) Pull out all inside layers connected to side marked by dotted line; repeat behind.

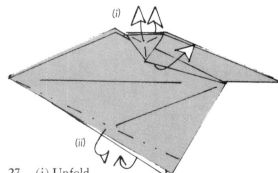

27. (i) Unfold.
 (ii) Fold inside; repeat behind.

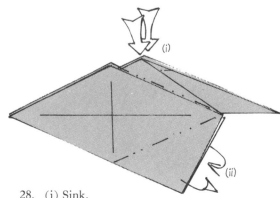

28. (i) Sink.
 (ii) Fold inside.

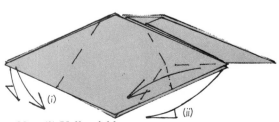

29. (i) Valley-fold.
 (ii) Rabbit ear; repeat behind.

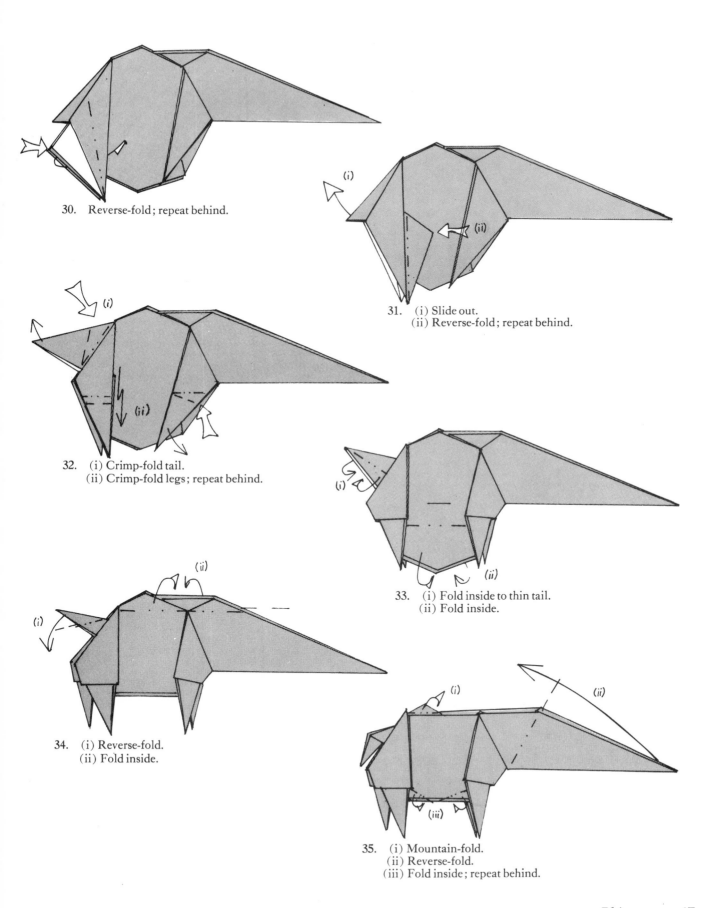

30. Reverse-fold; repeat behind.

31. (i) Slide out.
 (ii) Reverse-fold; repeat behind.

32. (i) Crimp-fold tail.
 (ii) Crimp-fold legs; repeat behind.

33. (i) Fold inside to thin tail.
 (ii) Fold inside.

34. (i) Reverse-fold.
 (ii) Fold inside.

35. (i) Mountain-fold.
 (ii) Reverse-fold.
 (iii) Fold inside; repeat behind.

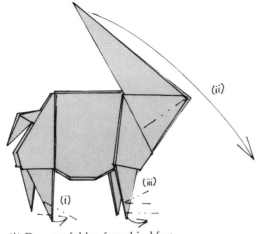

36. (i) Reverse-fold to form hind feet.
 (ii) Reverse-fold.
 (iii) Crimp-fold to form front feet.

37a. Pleat-fold.

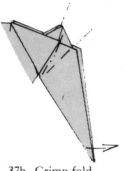

37b. Crimp-fold.

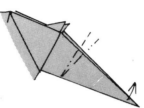

37c. Inside crimp-fold.

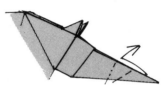

37d. Inside reverse-fold twice.

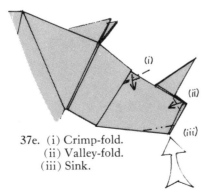

37e. (i) Crimp-fold.
 (ii) Valley-fold.
 (iii) Sink.

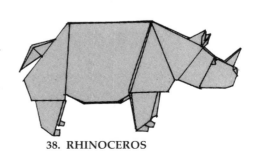

38. RHINOCEROS